DRAWING ON ANXIETY

FINDING CALM THROUGH CREATIVITY

Leaping Hare Press

First published in 2023 by Leaping Hare Press, an imprint of The Quarto Group.

The Old Brewery, 6 Blundell Street
London, N7 9BH,
United Kingdom
T (0)20 7700 6700
www.Quarto.com

A catalogue record for this book is available from the British Library.

ISBN 978-0-7112-7936-0
Ebook ISBN 978-0-7112-7937-7

10 9 8 7 6 5 4 3 2 1

Commissioning editor Monica Perdoni
Project editor Joe Hallsworth
Cover and interior illustrations by Kate Sutton
Design by Renata Latipova

Printed in China

MIX
Paper | Supporting
responsible forestry
FSC® C008047

DRAWING
ON ANXIETY
FINDING CALM THROUGH CREATIVITY

KATE SUTTON

INTRODUCTION

IT'S NORMAL TO get ANXIOUS — IT'S A VERY NATURAL HUMAN RESPONSE. THE PROBLEM IS WHEN IT TAKES HOLD and STOPS US LIVING TO OUR FULL POTENTIAL. A POSITIVE THING THAT CAN COME FROM ANXIETY IS THAT IT CAN BE A SIGN THAT SOME THINGS IN YOUR LIFE, and IN YOU, ARE OUT OF ALIGNMENT AND NEED ADDRESSING.

WITH CHRONIC ANXIETY, OUR SYSTEMS ARE in A STATE OF FLIGHT OR FIGHT LONG AFTER THE SUPPOSED THREAT HAS PASSED. I KNOW HOW CRIPPLING and TERRIFYINGLY OVER-WHELMING ANXIETY CAN BE.

THE IDEA OF this BOOK ISN'T TO GET RID of ANXIETY but I HOPE IT OFFERS A BALM to YOUR SYSTEM WHEN YOU FEEL YOURSELF

SPIRALLING OR GETTING LOST IN YOUR OWN THOUGHTS.

THE HOPE IS THAT THIS BOOK WILL BRING YOU OUT OF YOUR HEAD and INTO YOUR BODY and THE PRESENT MOMENT THROUGH THE use of DRAWING. DRAWING CALLS FOR US TO BE MORE PRESENT, IT ALLOWS the FLOW STATE, AND ENCOURAGES US TO BE MINDFUL and TO FULLY FOCUS ON THE TASK at HAND, WHICH CAN BE EVER SO SOOTHING.

I HOPE THAT THIS BOOK ALSO HELPS you CULTIVATE MORE AWARENESS OF YOURself, YOUR ANXIETY, the TRIGGERS, THE SENSATIONS In your BODY, and THE THINGS THAT HELP and THAT DON'T.

IN THIS BOOK I SHARE SOME OF MY PERSONAL EXPERIENCES WITH ANXIETY, FROM THE intense GRIP HEALTH ANXIETY HAD OVER ME FOR MANY YEARS, TO MY LOUD INNER CRITIC and TO SMALLER daily STRESSORS AND WORRIES.

I FOUND the ACT OF DRAWING THEM OUT SHIFTED SOMEthing IN ME SLIGHTLY, I HOPE YOU WILL FIND a SIMILAR RELEASE.

I WILL SHOW YOU SOME OF THE daily THINGS I DO TO HELP PUT SOME STRUCTURE and ROUTINE INTO the UNCERTAIN WORLD WE LIVE IN, AND THE tools I USE FOR INSTANT CALM - THE BIG ONE BEING DRAWING!

ANXIETY, STRESS, WORRY, and FEAR. WHAT'S THE DIFFERENCE?

ALTHOUGH IT PROMPTS SIMILAR FEELINGS and EXPERIENCES, anxiety IS DISTINGUISHABLE FROM FEAR, WORRY AND STRESS, and CAN BE SOMETHING THAT BUBBLES UNDER THE SURFACE WITHOUT YOU REALISING. FOR EXAMPLE, ALTHOUGH THEY ARE BOTH EXPERIENCED PHYSICALLY AND EMOTIONALLY, FEAR is A RESPONSE TO AN IMMINENT THREAT, WHEREAS ANXIETY STEMS FROM an UNKNOWN, OR FUTURE THREAT.

WORRY IS THOUGHT-RELATED and IS MORE LIKELY TO LEAD TO PROBLEM SOLVING. WHAT FEAR, WORRY and ANXIETY HAVE IN COMMON is THAT THEY'RE A RESPONSE TO A PERCIEVED THREAT.

STRESS IS DIFFERENT FROM THESE THREE. A CERTAIN AMOUNT OF STRESS IS INEVITABLE, NOT TO MENTION ADAPTIVE, HEALTHY AND CAN LEAD TO IMPROVED PERFORMANCE and EFFICIENCY. STRESS IS ALLEVIATED WHEN EXTERNAL STRESSORS are ABSENT, WHEREAS ANXIETY'S ORIGIN IS INTERNAL and PERSISTS REGARDLESS OF WHETHER these STRESSORS ARE present OR NOT.

THE FOUR TERMS DO INTERRELATE, BUT THEY ARE different, and BY UNDERSTANDING THE DIFFERENCES BETWEEN THEM, WE CAN BETTER IDENTIFY OUR ANXIETY.

HOW to USE THIS BOOK

THERE is NO PARTICULAR STRUCTURE or ORDER to THIS BOOK - you MAY CHOOSE TO WORK THROUGH the PROMPTS FROm the START OR YOU ARE FREE TO DROP in AND OUT as YOU WISH. SOME PROMPTS MAY CALL TO YOU MORE THAN OTHERS AT CERtain TIMES DEPENDING ON HOW YOU ARE FEELING.

I KNOW AN EMPTY PAGE Can FEEL A LITTLE DAUNTing, but I'd LOVE IT if you COULD RELEASE SOME of THAT FEAR AND DRAW LIKE WHEN YOU WERE A CHILD, WITHOUT JUDGEMENT.

THERE'S NO RIGHT or WRONG WAY - JUST SELF-DISCOVERY AND PLAY!

THIS BOOK is A PRIVATE PLACE FOR YOU TO EXPRESS YOURSELF, and IT'S MORE ABOUT the PROCESS THAN the END RESULT.

YOU CAN USE WHATEVER MEDIUM you LIKE; I FIND FELT TIPS, FINELINERS and PENCIL CRAYONS ARE MY GO-TO.

ALL OF THE PROMPTS ENCOURAGE YOU TO BE MORE AWARE - AWARE of YOUR THOUGHTS, YOUR FEELINGS, YOUR BODY AND THE WORLD AROUND you. SOME ARE SIMPLY ABOUT BRINGING you IN TO THE PRESENT MOMENT.

MINDFULNESS

WE LIVE in A WORLD WHERE WE ARE CONSTANTLY 'ON' and ALWAYS AVAILABLE, and WE ARE MOVING SO FAST THAT WE BARELY STOP TO TAKE A BREATH.

WE ARE OVER-STIMULATED and BOMBARDED WITH SO MUCH INFORMATION. IT'S TOO MUCH FOR OUR SYSTEMS TO DEAL WITH, and THIS IS WHERE 'MINDfulness' CAN HELP US.

MINDfulness CALLS FOR US TO BE IN THE PRESENT MOMENT – TO LEAVE the PAST and STOP FOCUSING ON THE FUTURE. ALL WE HAVE is THIS MOMENT Right NOW and THERE is COMFORT IN KNOWING THIS.

WAYS TO ENCOURAGE MINDfulness CAN BE PAYING CLOSE ATTENTION TO YOUR BODY or THE WORLD AROUND YOU, and FOCUSING ON WHAT is IMMEDIATELY HAPPENING.

IT'S NOTICING THE TINY THINGS LIKE THE WIND BLOWING A LEAF, OR THE ITCH on YOUR NOSE. WE CAN PRACTICE MINDfulness THROUGHOUT OUR DAY, BRINGING FULL ATTENTION TO WHAT WE ARE DOING RIGHT NOW. THIS CAN HELP CALM THE MIND IMMEDIATELY. IN THIS BOOK WE ARE USING DRAWING AS A FORM OF MINDfulness BY PUTTING ALL OUR FOCUS ON MAKING MARKS ON THE PAGE.

DRAW ABOUT A RECENT time WHEN you FELT FULLY IN THE PResent moment.

NATURE

YOU WILL SEE THAT NATURE FEATURES HEAVILY IN THIS BOOK; nature HAS LONG BEEN USED AS A WAY TO RECONNECT WITH OURSELVES and SLOW DOWN IN THE FRANTIC WORLD THAT WE LIVE in. IT HAS BEEN PROVEN TO REDUCE SYMPTOMS OF ANXIETY AND DEPRESSION, and HAS A WAY OF CALLING US TO BE MORE PRESENT.

IT CAN MAKE ME FEEL REASSURINGLY SMALL AND CAN PUT MY WORRIES INTO PERSPECTIVE. IT CAN TEACH US SO MUCH, THE CYCULAR NATURE of IT ALL, BY REMINDING US THAT LIFE is EVER-CHANGING AND THAT NOTHING is PERMANENT, WHICH IN ITSELF MAKES IT MORE BEAUTIful.

IT'S ALSO AMAZING TO LOOK AT THE WAY ANIMALS DEAL WITH STRESS: THE stress-INDUCING EVENT HAPPENS and THEIR SYSTEM RESPONDS TO KEEP them SAFE. ONCE OUT OF DANGER THEY HAVE A GOOD SHAKE AND GO ABOUT THEIR business.

STUDIES HAVE SHOWN THAT EVEN GETTING OUT AND LOOKING AT A tree FOR A FEW MINUTES or even JUST LOOKING AT IMAGES of THE NATURAL WORLD, CAN HAVE POSITIVE IMPLICATIONS. THIS IS WHY I LOVE TO MIX NATURE AND DRAWING AS IT FEELS LIKE A VERY POWERFUL COMBINATION.

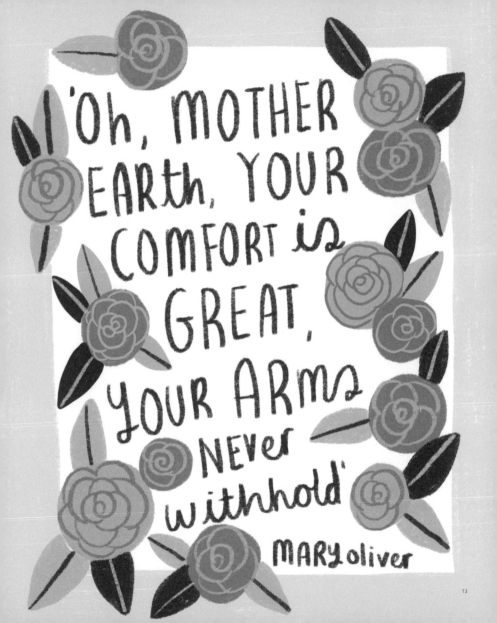

'Oh, MOTHER EARTH, YOUR COMFORT is GREAT, YOUR ARMs NEVER withhold'

MARY oliver

FILL these bubbles with any thoughts or
WORRIES THAT ARE RUNNING THROUGH YOUR MIND.

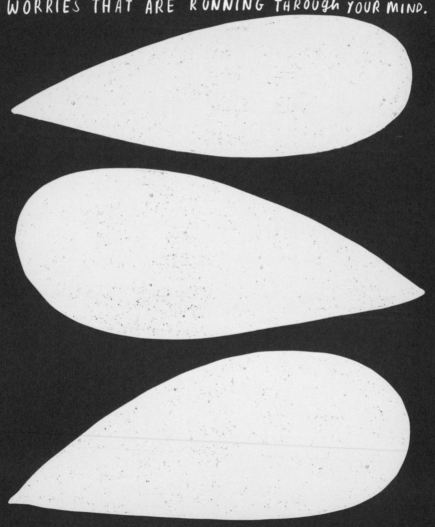

ONE OF THE KINDEST THINGS WE CAN DO FOR OURSELVES IS TO LEARN TO SAY NO. ESPECIALLY DURING TIMES OF STRESS and ANXIETY. FILL THESE PAGES WITH 'NO'S' IN ALL SORTS of FONTS, COLOURS and SIZES.

no

NO!

NO

WORRY DOLLS are TINY HANDMADE DOLLS, MOST OFTEN MADE in GUATEMALA. PEOPLE WOULD TELL the DOLLS THEIR CONCERNS BEFORE BED, then PLACE them UNDER their PILLOW and THE WORRIES WOULD go AWAY OVERNight. FILL these PAges WITH BRightly COLOURed WORRY DOLLS, and WRITE ANY WORRies ALONGSide EACH doll if YOU WISH.

HAVE FUN WITH PATTERNS and COLOURS on THEIR OUTFITS.

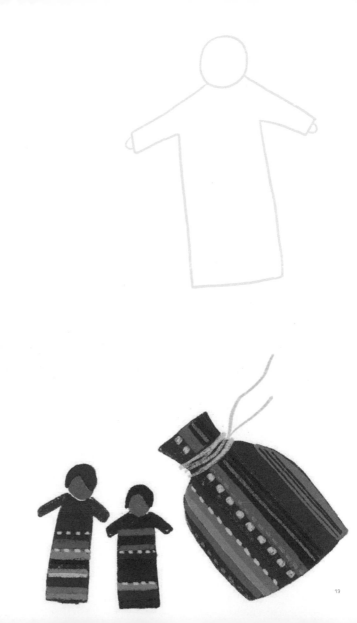

THINGS I FIND MYSELF doing MORE of WHEN I'M UNHAPPY and ANXIOUS.

INCESSANT SCROLLING

TRASHY TV BEFORE BED

CRAVING & EATING all THE SWEET STUFF

LESS RUNNING and DRAWING

DRAW any BEHAVIOURS or HABITS you
NOTICE YOURSELF DOING DURING TIMES of
STRESS.

IMAGINE YOU ARE ONE OF THESE BIRDS FLYING HIGH. DRAW THE VIEW YOU can see.

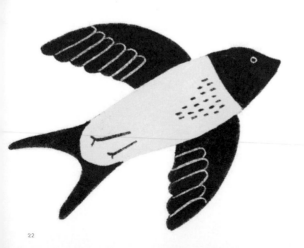

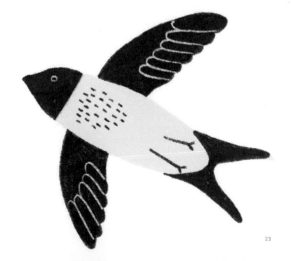

SOMETIMES IT CAN FEEL like YOU ARE A TINY BOAT CAUGHT in A TERRIBLE STORM AT SEA. FINISH THIS DRAWING BY ADDING TEXTURE AND DETAIL TO THE SEA and SKY.

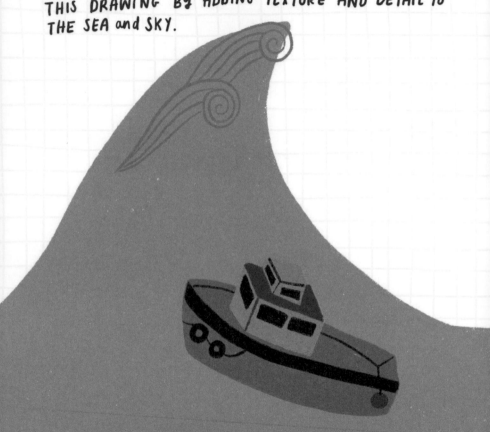

IT'S COMFORTING TO KNOW THAT ALL STORMS PASS. NOW IMAGINE YOU ARE this LITTLE BOAT ON CALMER SEAS. FINISH OFF the DRAWING; MAYBE you WANT TO ADD A BEAUTIFUL SKY or PATTERNS TO THE SEA.

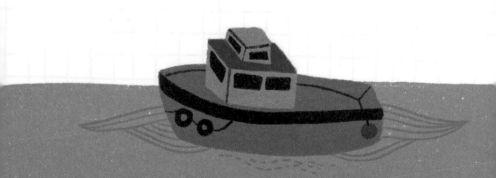

THINGS THAT MAKE ME FEEL CALM.

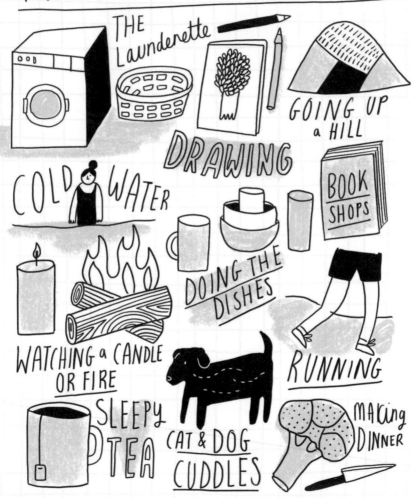

THE Launderette

DRAWING

GOING UP a HILL

COLD WATER

BOOK SHOPS

DOING THE DISHES

WATCHING a CANDLE OR FIRE

RUNNING

SLEEPY TEA

CAT & DOG CUDDLES

MAKING DINNER

DRAW SOME THINGS THAT MAKE YOU FEEL a little CALMER.

WE RARELY SIT AND DO NOTHING, THAT'S WHY
THERE'S SOMETHING QUITE WONDERFUL ABOUT SITTING
ON A TRAIN AND JUST STARING OUT OF THE WINDOW.

FROM YOUR IMAGINATION, DRAW WHAT YOU CAN SEE, WHAT'S THE WEATHER LIKE? CAN YOU SEE ANY WILDLIFE?

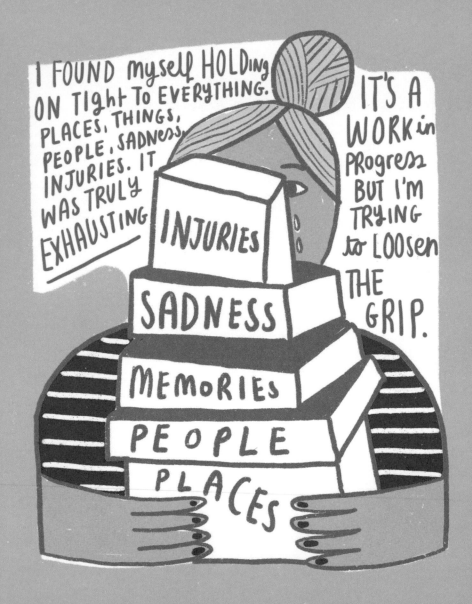

CAN YOU see any areas of your life where you could Loosen the grip? Draw about them here.

YOU deserve the LOVE and KINDNESS you
FREELY offer others. WRITE YOURSELF a letter.

DO YOU HAVE A FAVOURITE PIECE OF CLOTHING
that FEELS SAFE and COMFORTABLE? DRAW IT HERE.

GOOD NEWS

WE ARE BOMBARDED WITH NEGATIVE NEWS STORIES. USE these PAGES TO WRITE A HEADLINE and ARTICLE ABOUT A POSITIVE STORY YOU HAVE HEARD. TALES of COMPASSION and JOY. ADD SOME DRAWINGS TO SUPPORT YOUR TEXT.

IS THERE A QUOTE, PHRASE, POEM OR WORD that YOU FIND COMFORT IN? TAKE SOME TIME TO DRAW IT HERE in A DECORATIVE WAY.

ALL WE HAVE IS NOW.

WHAT WOULD YOU DO IF YOU WEREN'T
AFRaid? DRAW ABOUT IT HERE.

SEEN ON MY WALK.

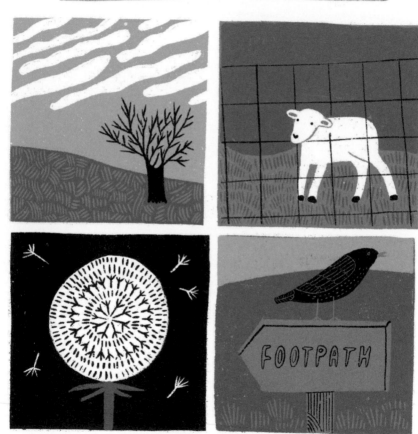

1. Beautiful mackerel sky. 2. Little lamb stuck in fence (he got out). 3. Seed heads blowing all around. 4. Noisy blackbird.

SEEN on MY RUN.

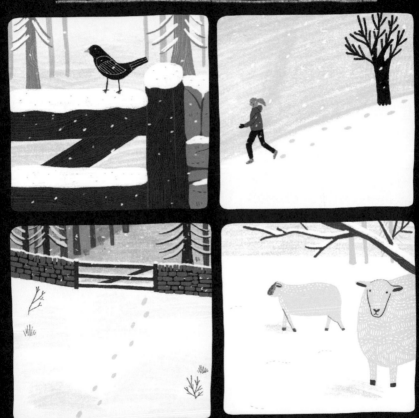

1. Blackbird sitting on a gate. 2. Soft fluffy snow. 3. Someone's footprints. 4. Lovely sheep.

TAKE YOURSELF ON A WALK and BE MINDFUL of THE WORLD
AROUND YOU. WHEN YOU GET HOME DRAW FOUR THINGS YOU SAW.
DATE: _____

TAKE YOURSELF ON A WALK and BE MINDful of THE WORLD
AROUND YOU. WHEN YOU GET HOME DRAW FOUR THINGS YOU SAW.
DATE: _____

ONE OF MY FAVOURITE things TO SEE in the SPRING ARE THE FERNS, UNFURLING. SPEND SOME TIME DRAWING MORE FERNS; IMAGINE THE FEELING OF RELAXING, OPENING UP, AND STRETCHING OUT LIKE THE FERNS AS YOU DO SO.

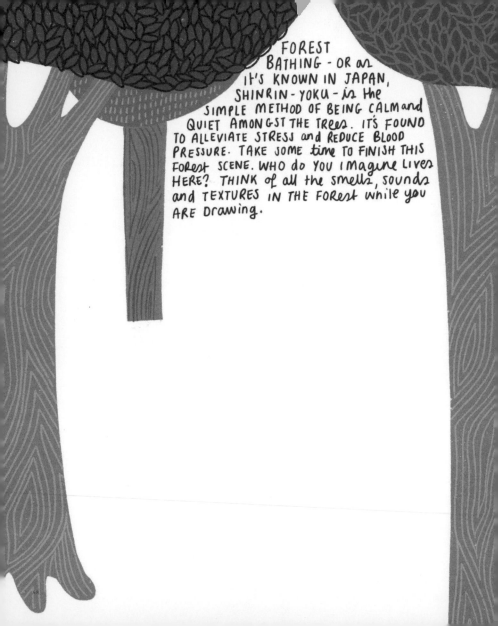

FOREST
BATHING - OR as
it's KNOWN IN JAPAN,
SHINRIN - YOKU - is the
SIMPLE METHOD OF BEING CALM and
QUIET AMONGST THE Trees. IT'S FOUND
TO ALLEVIATE STRESS and REDUCE BLOOD
PRESSURE. TAKE SOME time TO FINISH THIS
FOREST SCENE. WHO do YOU Imagine Lives
HERE? THINK of all the smells, sounds
and TEXTURES IN THE FOREST while you
ARE Drawing.

I ALWAYS feel a spark of JOY WHEN I SEE NATURE FINDING A WAY, LIKE PLANTS GROWING OUT OF TINY CRACKS IN THE PAVEMENT. FILL these PAGES WITH FLOWERS, FLOURISHING DESPITE THE CONDITIONS.

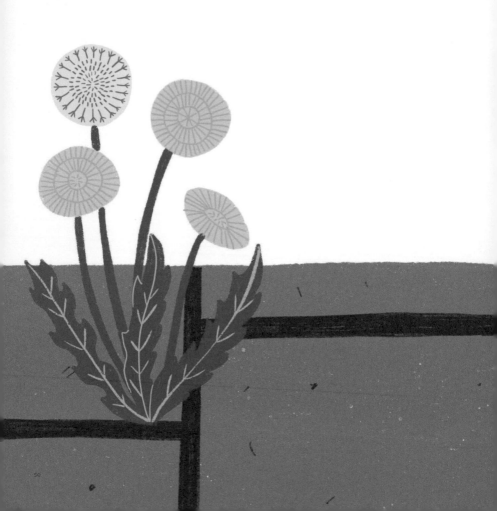

NATURE TABLE

TAKE YOURSELF ON A WALK and COLLECT FOUR or FIVE things FROM NATURE. DRAW THEM HERE WHEN YOU GET HOME. LOOK CLOSELY AT THE COLOURS and PATTERNS.

WHEN I FEEL OVERWHELMED I LIKE TO REMIND MYSELF HOW SMALL I AM IN THE UNIVERSE. MOUNTAINS always MAKE ME FEEL like THIS.

TAKE SOME time TO FINISH DRAWING this MOUNTAIN RANGE.

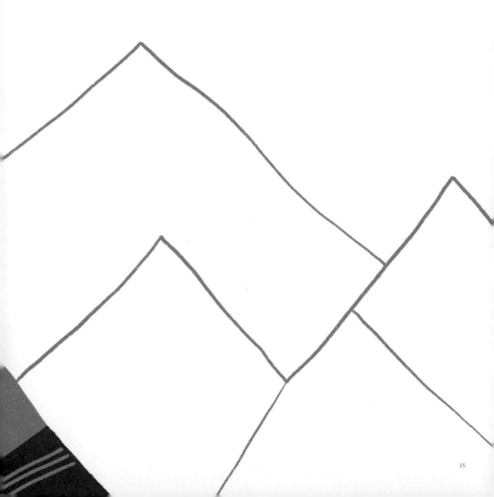

A FEW of MY FAVOURITE things

sometimes when I feel low, I like to remind myself of the things I love: chats with strangers on a Run, FIZZY water, NEW SOCKS. Draw all your fave things.

MORNING ROUTINE

I DON'T MANAGE this EVERYDAY, but all these THINGS HELP my FRAME of MIND for THE day AHEAD.

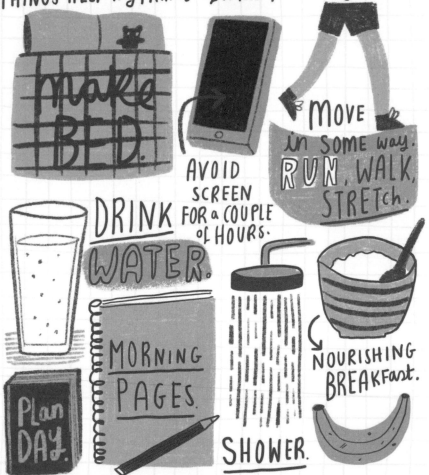

make BED.

AVOID SCREEN FOR a COUPLE of HOURS.

MOVE in SOME way. RUN, WALK, STRETCH.

DRINK WATER.

PLAN DAY.

MORNING PAGES.

NOURISHING BREAKFAST.

SHOWER.

DRAW YOURSELF a HELPFUL MORNING ROUTINE.

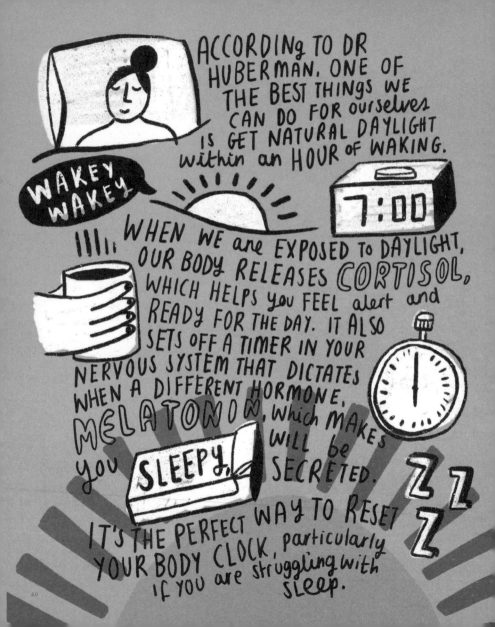

ACCORDING TO DR HUBERMAN, ONE OF THE BEST THINGS WE CAN DO FOR ourselves IS GET NATURAL DAYLIGHT within an HOUR of WAKING.

WAKEY WAKEY

7:00

WHEN WE are EXPOSED TO DAYLIGHT, OUR BODY RELEASES CORTISOL, WHICH HELPS you FEEL alert and READY FOR THE DAY. IT ALSO SETS OFF A TIMER IN YOUR NERVOUS SYSTEM THAT DICTATES WHEN A DIFFERENT HORMONE, MELATONIN, which MAKES you SLEEPY, WILL be SECRETED.

ZZZZ

IT'S THE PERFECT WAY TO RESET YOUR BODY CLOCK, particularly if you are struggling with SLEEP.

TRY GETTING OUTSIDE FOR ten MINUTES FIRST THING IN THE MORNING. USE IT AS a TIME TO DRAW HERE, What can you SEE, SMELL, and HEAR.

IN 'THE ARTIST'S WAY' BY JULIA Cameron, SHE INTRODUCES THE IDEA of MORNING PAGES. I FAILED to FINISH THE BOOK but I DID keep up MY PAGES and I FIND THEM so BENEFICIAL.

MORNING PAGES are 'THREE PAGES of LONG HAND, STREAM of CONSCIOUSNESS WRITING, DONE FIRST thing IN THE MORNING.'

YOU BASICALLY WRITE or DRAW anyThing THAT COMES UP FOR YOU. AS JULIA SAYS, 'THERE is NO WRONG WAY TO DO MORNING PAGES.'

I FIND them VERY CALMING - I INVITE you TO TRY IT ON THE FOLLOWING THREE PAGES!

65

THINGS to HELP YOU SLEEP BETTER.

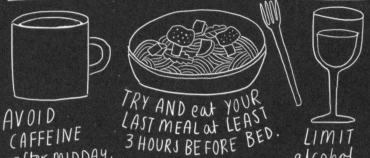

AVOID CAFFEINE after MIDDAY.

TRY AND eat YOUR LAST MEAL at LEAST 3 HOURS BEFORE BED.

LIMIT alcohol.

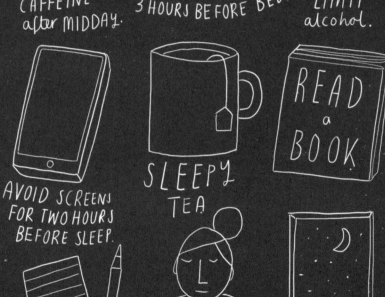

AVOID SCREENS FOR TWO HOURS BEFORE SLEEP.

SLEEPY TEA

READ a BOOK

WRITE A LIST OF WHAT YOU NEED TO DO TOMORROW

TAKE 10 deep breaths, exhaling slowly

KEEP YOUR ROOM COOL

BEFORE BED, USE THIS PAGE TO EMPTY YOUR BRAIN. DRAW or WRITE anything THAT WANTS TO BE RELEASED.

DRAW A RECENT DREAM.

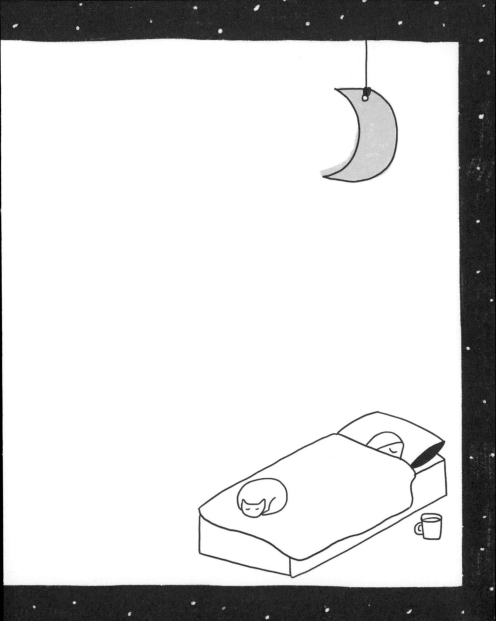

PET THERAPY - OUR FURRY FRIENDS ARE SAID TO REDUCE STRESS. I FIND IT VERY COMFORTING WATCHING CATS and DOGS GO ABOUT THEIR BUSINESS. FILL THESE PAGES WITH MORE OF THEM DOING WHAT THEY DO - NOT WORRYING ABOUT the STRESSES OF MODERN LIFE.

ONE WAY I TRY and SHOW myself LOVE and
COMPASSION IS BY EATING Lots of FRUIT and
VEG. IT DOESN'T ALWAYS HAPPEN! FILL these
PAGES WITH LOTS of FUNNY FRUIT and VEG.

DRAW the VIEW FROM YOUR WINDOW. ADD THE 'WEATHER'. THE WEATHER REPRESENTING YOUR THOUGHTS and FEELINGS AT THIS MOMENT. WRITE a LITTLE 'WEATHER REPORT' ABOUT HOW YOU ARE FEELING HERE. ↓

You Are not Your thoughts

SPEND A FEW MINUTES OBSERVING YOUR THOUGHTS.
WRITE SOME OF THEM IN THESE CLOUDS AND I MAGINE
THEM DRIFTING
AWAY.

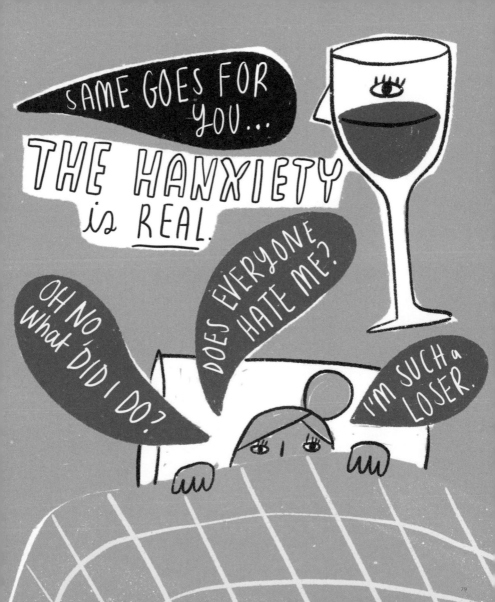

WHEN I FEEL OVERWHELMED I LIKE
TO LOOK AT things WAY bigger than me.
It can help me gain SOME
PERSPECTIVE. take
SOME time TO
ADD lots of detail
TO the moon and
OWL.

My mind can run away with me when I'm podrly. Especially if I'm alone... I never just allow myself to rest and get well. I'm constantly monitoring and looking for symptoms

Must google all possible symptoms of kidney infection.

Sometimes I can catch myself and offer myself compassion. Other times I SPIRAL!

We are constantly connected and available—
I FIND this overwhelming. My go-to comfort when I'm
stressed and anxious is my phone. It's my ultimate
distraction FROM difficult emotions. What's more
helpful FOR me, is to put my phone away and go
outside.

and go outside...

NEXT time you FIND YOURself mindlessly
scrolling, grab some pens and fill this
page with anything that comes out!

COLOUR IN!

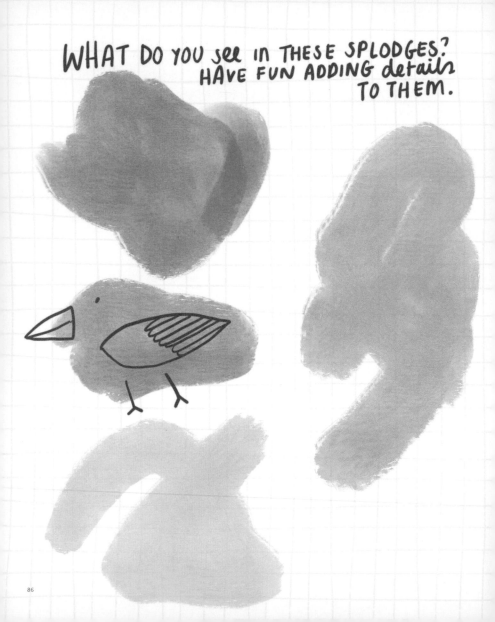

WHAT DO YOU see IN THESE SPLODGES?
HAVE FUN ADDING details
TO THEM.

THERE is VERY little IN LIFE We HAVE CONTROL OVER. NEXT time you FIND YOURSELF GRASPING and WANTING TO CONTROL THINGS, FILL THESE PAGES WITH orderly GEOMETRIC PATTERNS.

EMPTY YOUR BAG or POCKETS in FRONT of YOU AND DRAW the CONTENTS HERE. THIS EXERCISE BRINGS YOU into THE Present MOMENT BY OBSERVING and DRAWING THE ITEMS.

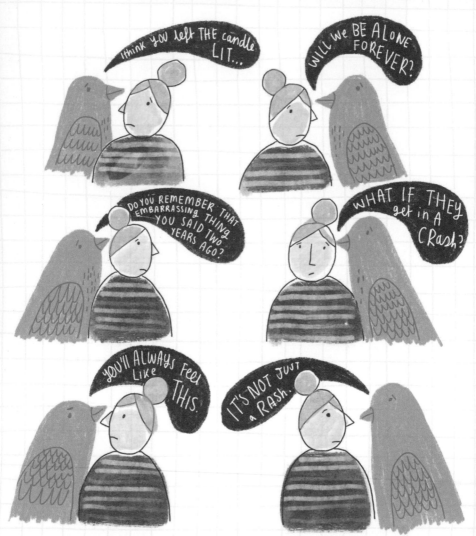

SOME things ANXIETY has told me LATELY.

DRAW YOURSELF with your ANXIETY, WRITE DOWN ANY OF THE THINGS IT HAS TRIED TO tell YOU LATELY.

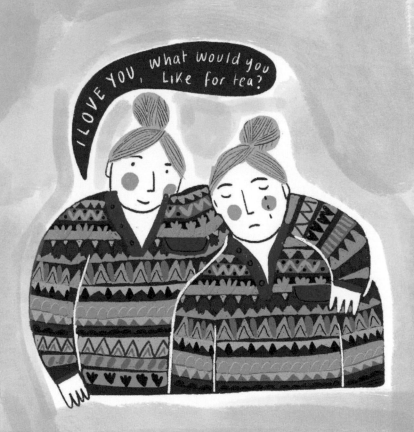

When I'm STRESSED and ANXIOUS I try and SHOW myself compassion. WHAT KIND things can you DO or SAY to yourself DURING difficult TIMEs? DRAW about them here.

When MY INNER CRITIC is LOUD it can Kill ALL JOY and CREATIVITY. I MOSTLY want to tell it to GET LOST and do something kind FOR myself. DRAW some ways you can show Kindness to yourself During these times.

DRAW YOUR INNER CRITIC.

WRITE a CONVERSATION WITH YOUR inner CRITIC. ANSWER BACK LIKE you ARE STICKING UP FOR YOUR BEST FRIEND.

ARE THERE any ACTIVITIES YOU DO THAT MAKE
YOUR INNER CRITIC REALLY LOUD? DRAW ABOUT it HERe.

I FIND it VERY COMFORTING to DRAW PATTERNS, IT helps my MIND SWITCH OFF. FILL THESE PAGES WITH PATTERNS you FIND in NATURE: FEATHERS, LEAVES, WATER RIPPLES!

OBSERVE YOUR THOUGHTS LIKE
YOU ARE BIRDwatching. YOUR
THOUGHTS BEING the BIRDS.
DRAW SOME BIRDS coming
and GOING FROM the
TABLE and FEEDER.

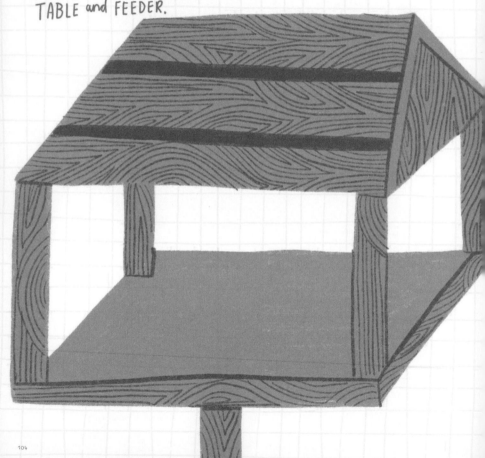

LITTLE WINS: DRAW three small things YOU achieved TODAY. DATE: _____

LITTLE WINS: DRAW three small things
YOU achieved TODAY. DATE: _____

IMAGINE YOUR ANXIETY is KNOCKING AT YOUR DOOR. WHAT does IT LOOK LIKE? WHAT does IT WANT TO TELL YOU? WE OFTEN AVOID DIFFICULT EMOTIONS WITH ANY distraction WE CAN, INCLUding RUMINATINg THOUghts. ALLOWING THE DIFFICULT EMOTIONS & FEELINgs TO BE THERE, WITHOUT AVOIDANCE can SOMETIMES HELP them DISSIPATE. LET'S INVITE them IN FOR TEA.

DRAW YOURSELF HAVING TEA and CAKE with THEM.

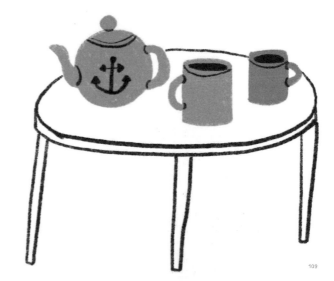

DRAW A PAGE OF RED THINGS.

DRAW A PAGE of YELLOW THINGS.

SHARING A POST ON SOCIAL MEDIA

I QUITE LIKE this DRAWING, I THINK I'LL SHARE it ON INSTAGRAM.

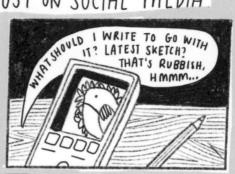

WHAT SHOULD I WRITE TO GO WITH IT? LATEST SKETCH? THAT'S RUBBISH, HMMM...

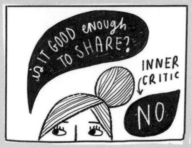

Is it GOOD enough TO SHARE?

INNER CRITIC

NO

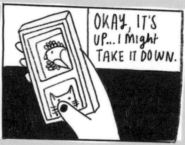

OKAY, IT'S UP... I MIGHT TAKE IT DOWN.

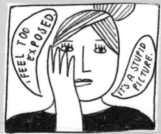

I FEEL TOO EXPOSED.

IT'S A STUPID PICTURE.

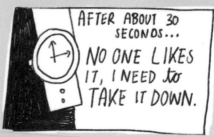

AFTER ABOUT 30 SECONDS... NO ONE LIKES IT, I NEED to TAKE IT DOWN.

DELETE POST

THE END... UNTIL I DECIDE to POST it again and REPEAT the PROCESS.

WHEN I'M STRESSED and ANXIOUS SOCIAL MEDIA
FUELS it EVEN MORE. IT's HELPful TO REMEMBER
that IT's NOT REAL LIFE. CAN YOU DRAW ABOUT a time
SOCIAL media HAS HEIGHTened YOUR ANXIETY? IT's KIND
TO UNFOLLOW ACCOUNTs that MAKE YOU feel BAD or EVEN
BETTER SET YOURSELF TIME LIMITS EACH DAY.

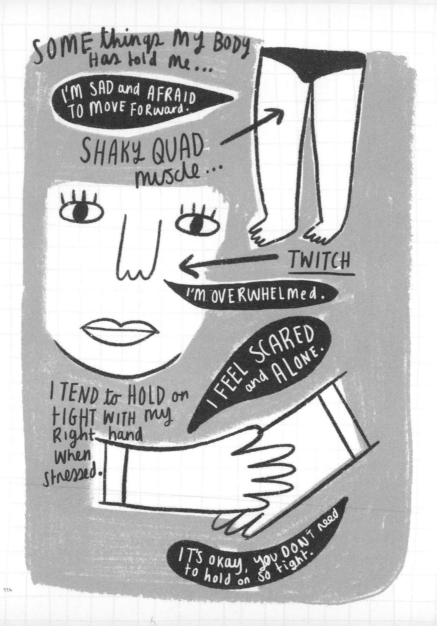

WHEN WE ALLOW OURSELVES TO BE STILL and QUIET in OUR BODies, IT CAN SEND US MESSAGES TO WHAT'S REALLY GOING ON. CLOSE YOUR EYES, PLACE YOUR HAND on YOUR HEART, and TAKE SEVERAL DEEP BReathes. HOW Does your heart FEEL TODAY? DRAW or WRITE ANYTHING THAT COMES UP; WORDS, SHAPES, TEXTURES...

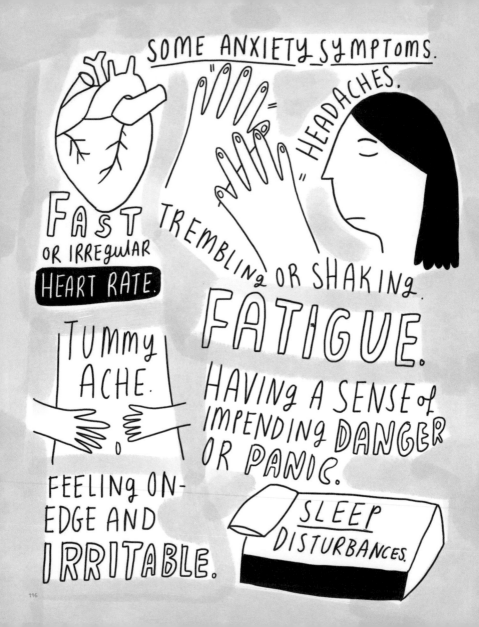

HOW DOES ANXIETY SHOW UP FOR YOU?
DRAW ANY SYMPTOMS HERE.

NOTHING soothes my system quite
LIKE getting in the LAKE FIRST
thing IN THE MORNING.
I LOVE the CONTRAST between
being ALL COZY in BED and STANDING
AT THE LAKE SHORE in MY COSTUME. IT
REMINDS ME I CAN DO difficult THINGS.
ON TOP of this, IT FORCES ME to BE
PRESENT, COMPLETELY IN MY BODY.
AFTER THE INITIAL 'THAT'S SO COLD!', THE
MIND BEGINS TO QUIET.

I BECOME AWARE OF all
THE SENSATIONS HAPPENING IN MY BODY,
and THEN I RELAX. THE CALM THAT COMES
AFTER being IN COLD WATER is WONDERFUL.
IT feels LIKE MY WHOLE BEING HAS been
RESET, and I CAN TAKE this FEELing
INTO THE REST of MY DAY.

'BEING AWARE OF YOUR BREATH FORCES YOU into THE PRESENT MOMENT.'

-ECKhart TOLLE

CLOSE YOUR EYES.
TAKE 10 Deep belly BREATHS.
OPEN YOUR EYES. DRAW
the FIRST thing your
EYES are DRawn TO.

GRATITUDE JOURNAL

THERE are MANY PROVEN BENEFITS to CREATING A GRATITUDE PRACTICE to SUPPORT YOUR WELL BEING. I'VE FOUND THAT EVEN IN THE DARKEST OF TIMES it CAN SHINE A TINY BIT of LIGHT.

I INVITE YOU TO DRAW FIVE things EACH DAY THAT YOU ARE GRATEFUL FOR, you CAN ADD ANY SUPPORTING TEXT THAT YOU LIKE.

THEY CAN BE the SMALLEST THINGS LIKE ENJOYING A CUP of COFFEE, DOING SOMETHING YOU HAVE BEEN PUTTING OFF, OR EVEN JUST PUTTING ON CLEAN, DRY SOCKS AFTER getting SOAKED in THE RAIN.

I THINK THE COMBINATION OF GRATITUDE and DRAWING is VERY POWERFUL, you GET BENEFITS on MANY LEVELS.

I LIKE TO DO MINE AT THE END OF THE DAY, BUT JUST FIND A TIME that WORKS FOR YOU - IT DOESN'T HAVE TO TAKE LONG, FIVE or TEN MINUTES SAT WITH YOURSELF is PERFECT.

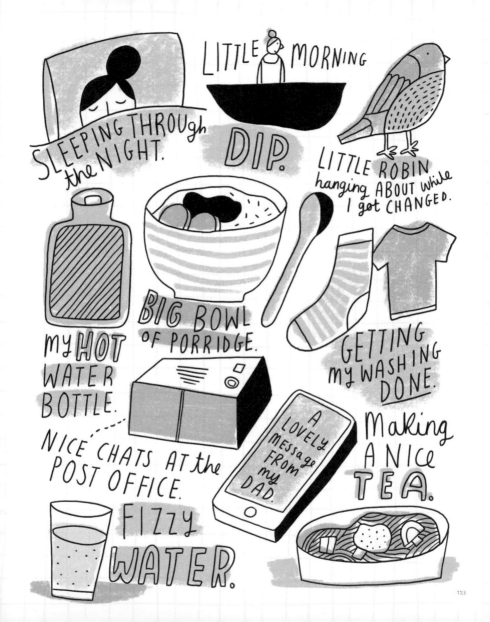

TODAY I'M GRATEFUL FOR:

DRAW or WRITE FIVE things.

DATE: _____

TODAY I'M GRATEFUL FOR:

DRAW or WRITE FIVE things.

DATE: _____

AFTER HANGING OUT WITH A FRIEND.

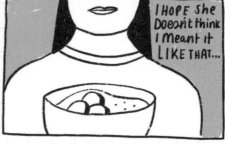

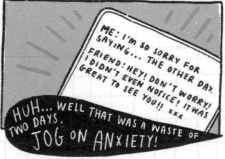

CAN YOU DRAW ABOUT A TIME WHEN YOUR MIND has MADE UP A STORY and YOUR ANXIETY and WORRY TOOK OVER?

THIS TOO

THE good AND THE BAD, it all PASSES.
I FIND SUCH COMFORT in THESE WORDS.
make yourself a BREW and take SOME
TIME out to colouR & DECORATE them.

SHALL PASS.

BODY SCAN

WE HOLD ALL OUR STRESS and PAST HURTS IN OUR BODY,
A GOOD WAY TO RELEASE THEM is TO BRING AWARENESS
TO THEM. BODY SCANS BRING US BACK to OUR BODIES AND
TAKE US OUT OF OUR OVERTHINKING MINDS.

1. LIE DOWN in A COMFORTABLE POSITION, ARMS BY YOUR SIDES.

2. CLOSE YOUR EYES and BEGIN BY TAKING SOME DEEP BELLY
 BREATHS, letting the EXHALATION RELEASE THROUGH YOUR
 MOUTH, and ALLOWING YOUR BREATHING TO SLOW DOWN.

3. NOW, Slowly bring YOUR ATTENTION TO YOUR FEET. PAY
 ATTENTION TO ANY SENSATIONS, TINGLING OR VIBRATING.
 ARE THEY COLD or WARM? DO YOU NOTICE ANY TENSION?
 IF YOU NOTICE any UNCOMFORTABLE SENSATIONS or PAIN,
 BREATHE into THEM and NOTICE IF THEY SUBSIDE.

4. CONTINUE the SCAN all THE WAY UP YOUR BODY,
 TAKING THE time TO FOCUS ON EACH AREA, and BREATHING
 INTO any AREAS OF TENSION YOU NOTICE. IMAGINE the
 TENSION DISSOLVING WITH EACH BREATH.

IF YOU DON'T HAVE MUCH TIME, YOU CAN JUST FOCUS YOUR
ATTENTION ON A SPECIFIC AREA of TENSION, PAIN OR
DISCOMFORT YOU ARE AWARE OF.

DRAW ANYthing
YOU NOTICE in
YOUR BODY;
SENSATIONS, COLOURS,
IMAGES.

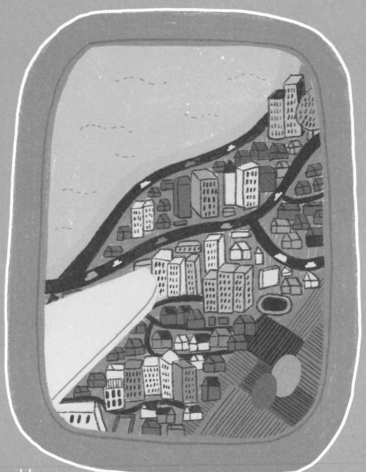

I LOVE LOOKING OUT OF A PLANE WINDOW and SEEING THE WORLD BELOW LIKE a PATCHWORK. I THINK OF ALL the PEOPLE going ABOUT THEIR lines. PEOPLE DYING, FALLING IN LOVE, BREAKING UP, ALL the WONDERful MESSINESS OF BEING HUMAN HAPPENING in THAT PATCHWORK. IT SOMEHOW makes ME FEEL LESS ALONE.

WHAT VIEW CAN YOU IMAGINE FROM this PLANE WINDOW?

THIS is MY 'TOOLKIT'.

IT DOESN'T STOP ME FEELING ANXIOUS OR SAD,
BUT IT DOES HELP ME FEEL MORE PRESENT and
ABLE to COPE.

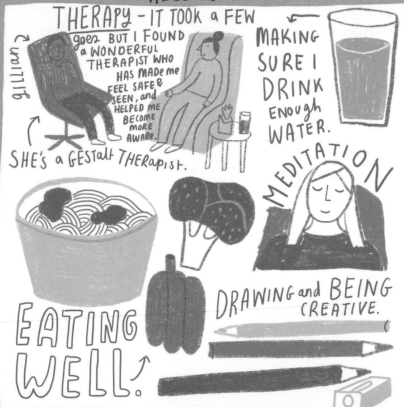

THERAPY – IT TOOK a FEW goes BUT I FOUND a WONDERFUL THERAPIST WHO HAS MADE me FEEL SAFE & SEEN, and HELPED ME BECOME MORE AWARE.

gillian

SHE'S a GESTALT THERAPIST.

MAKING SURE I DRINK ENOUGH WATER.

MEDITATION

EATING WELL.

DRAWING and BEING CREATIVE.

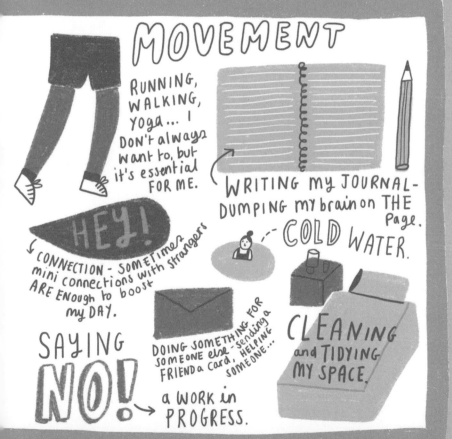

MOVEMENT

RUNNING, WALKING, YOGA... I DON'T always want to, but it's essential FOR ME.

WRITING MY JOURNAL—DUMPING my brain on THE page.

HEY!

↳ CONNECTION — SOMETIMES mini connections with strangers ARE ENOUGH to boost my DAY.

COLD WATER.

DOING SOMETHING FOR SOMEONE else — sending a FRIEND a card, HELPING SOMEONE...

CLEANING and TIDYING MY SPACE.

SAYING NO!

→ a WORK in PROGRESS.

DRAW YOUR OWN
TOOLKIT of THINGS THAT HELP.

SURROUND this cosy Little LOG CABIN WITH TREES so that it's deep IN THE FOREST. IMAGINE the healing power of switching off and being surrounded by nature.

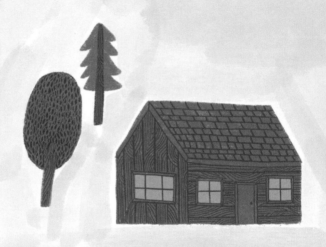

'this belongs.'

TARA BRACH

IF Things FEEL heavy or I'M SPIRalling.
I TAKE enormous comfort in these words;
TRYing to ACCEPT whatever I'M EXPERiencing
AS IT is without trying to Change it, push it
AWAY, AVOID it, Numb it. JUST being with it
as it is.

DRAW ABOUT A time you ALLOWED
Things TO BE EXACTLY as they were.

THE PEACE OF WILD THINGS

WHEN DESPAIR FOR THE WORLD GROWS IN ME
and I WAKE IN THE NIGHT AT THE LEAST SOUND
IN FEAR OF WHAT MY LIFE AND MY CHILDREN'S LIVES MAY BE,
I GO AND LIE DOWN WHERE THE WOOD DRAKE
RESTS IN HIS BEAUTY on THE WATER, and THE GREAT HERON FEEDS.
I COME INTO THE PEACE OF WILD THINGS
WHO DO NOT TAX THEIR LIVES WITH FORETHOUGHT
OF GRIEF. I COME INTO THE PRESENCE OF STILL WATER.
AND I FEEL ABOVE ME THE DAY-BLIND STARS
WAITING WITH THEIR LIGHT. FOR A TIME
I REST IN THE GRACE OF THE WORLD, and AM FREE.

— WENDELL BERRY

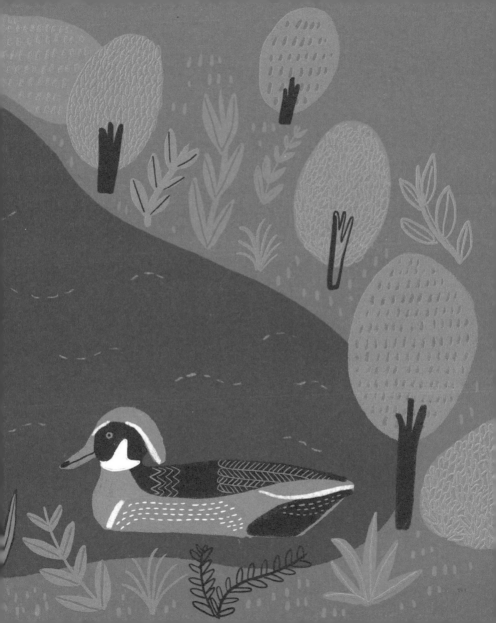

I LOVE the MIX of NEW LIFE and OLD during SPRINGTIME; A nice reminder of THE cyclical NATURE OF EVERYTHING. FILL this PAGE WITH signs OF SPRING.

'TO PAY attention, THIS is OUR ENDLESS and PROPER WORK.'

-MARY OLIVER

IMAGINE YOU are WALKING THROUGH an ALPINE MEADOW. FILL these PAGES WITH the FLOWERS and ANIMALS YOU CAN SEE.

'THE *trees* ARE ABOUT TO SHOW US HOW LOVELY IT *is* TO LET THE DEAD THINGS GO.' — UNKNOWN

FIND TWO TYPES of LEAVES and DRAW THEM here.
LOOK CLOSLY AT the WONDERFUL PATTERNS and
TEXTURES, and HOW DIFFERENT THEY ARE.

—————————— coLour this Page.

IF We LOOK TO NATURe, WinteR can be a
WONDERful TIME FOR SLOWING DOWN,
RESTINg and RESETTing. WE Can't be 'on' all of
THE TIME. FILL THese PAGES with SOME things
YOU ENJOY about WINTER.

'IN THE MIDST OF WINTER, I FOUND there WAS, WITHIN me, AN INVINCIBLe summer.'

— ALBERT CAMUS

INDEX

RESOURCES

THERAPY

I'M A HUGE ADVOCATE FOR THERAPY. I'VE been LUCKY enough to hAVE been SEEING GILLIAN FOR 3 YEARS and IT's changed my LiFe. She specializes in GESTALT Therapy. IF YOU ARE iN A POSITION TO and ARE INTERESTED in FINDING A THERAPIST YOU CAN LOOK ON BACP. CO. UK

DOMĚSTIKA

ILLUSTRATED LiFe JOURNAL: A DAILY MINDful PRACTICE.

My Domestika course encourages you to cReate a daily Drawing habit, using you and Your Life as the main FOCUS.
Domestika.org

I'M A BIG FAN of THE CALM APP. It's full of guided MEDITATIONS AND, MAybe my FAVOURITE BIT, THE Lovely SLEEP STORIES.
calm . com

CALM ®
a magnesium supplement

NATURAL VITALITY

anti-stress DRINK. mental stress can deplete the magnesium in your body. I take this each night before bed & it really helps me sleep.

TARA BRACH is a MEDITATION teacher and PSYCHOLOGIST. YOU can FIND her talks & guided meditations at www.tarabrach.com; she has developed an amazing technique called RAIN which is so helpful FOR anxiety.

BRILLIANT FILM BY THE AMazing DR GABOR MATÉ
THEWISDOMofTRAUMA.com

THE WISDOM OF TRAUMA

SOME podcasts...

FEEL BETTER, LIVE MORE.

DR RANGAN CHATTERJEE OFFERS GREAT INSIGHT INTO HOW TO heal and live a more awake life.

HUBERMAN LAB

DR ANDREW Huberman discusses science & science-based tools for everyday life.

HOW TO FAIL

WITH ELIZABETH DAY

HAPPY PLACE

WONDERFUL conversations WITH FEARNE COTTON ON THE COMPLEXITIES OF BEING HUMAN.

VESPER FLIGHTS - HELEN MACDONALD

'AT TIMES OF DIFFICULTY, WATCHING BIRDS USHERS YOU INTO A DIFFERENT WORLD, WHERE NO WORDS NEED TO BE SPOKEN.'

HAPPY MIND, HAPPY LIFE - DR RANGAN CHATTERJEE

I'M A BIG FAN OF THE WORK RANGAN DOES - HE GIVES PEOPLE BACK CONTROL and POWER TO MAKE POSITIVE CHANGES IN THEIR LIVES. IN THIS BOOK HE OFFERS SIMPLE WAYS THAT CAN LEAD PEOPLE TO LIVE A LIGHTER, MORE JOYful LIFE BY BEING TRUE TO THEMSELVES.

Vesper Flights HELEN macdonald

Happy Mind, Happy Life Dr RANGAN CHATTERJEE

This Too Shall pass JULIA SAMUEL

BESSEL van der KOLK THE BODY KEEPS THE SCORE

WINTERING KATHERINE MAY

Fear Less Dr Pippa Grange

RUTH ALLEN GROUNDED

THIS TOO SHALL PASS - JULIA SAMUEL

ANOTHER BRILLIANT BOOK BY JULIA SAMUEL. I am A BIG BELIEVER IN THE POWER of THERAPY, and THIS BOOK is FULL OF WONDERFUL CASE STUDIES and, MORE IMPORTANTLY, OF HOPE.

THE BODY KEEPS THE SCORE - BESSEL VAN DER KOLK, MD

A LIFE-CHANGING BOOK FOR MANY, ME INCLUDED. 'NEUROSCIENCE RESEARCH SHOWS THAT THE ONLY WAY WE CAN CHANGE THE WAY WE FEEL IS BY BECOMING AWARE OF OUR INNER EXPERIENCE and LEARNING TO BEFRIEND WHAT is GOING ON INSIDE OURSELVES.'

WINTERING - KATHERINE MAY

I TOOK SO MUCH COMFORT IN THIS BOOK and RECOMMEND IT TO EVERYONE; WE AREN'T BUILT TO BLOOM ALL OF THE TIME, ESPECIALLY IN THE WORLD WE LIVE IN. 'We have SEASONS WHEN WE FLOURISH and SEASONS WHEN THE LEAVES FALL FROM US, REVEALING OUR BARE BONES. GIVEN TIME, THEY GROW AGAIN.'

FEAR LESS - DR PIPPA GRANGE

IN THIS BOOK, PIPPA SHOWS ALL OF US HOW, BY STARTING TO LIVE WITH LESS FEAR, WE CAN FIND OUR REAL PASSIONS and DEEPER FULFILMENT. HER SIMPLE MANIFESTO ENABLES US TO REPLACE STRESS WITH COURAGE and CONNECT WITH THE PEOPLE AROUND US ON A FAR DEEPER level.

GROUNDED - RUTH ALLEN

BOTH BEAUTIFULLY WRITTEN and PRESENTED, RUTH DISCUSSES HOW DEEPLY DISCONNECTED WE HAVE BECOME and HOW WE CAN FIND OUR WAY BACK TO OURSELVES WITH THE HEALING POWER of THE NATURAL WORLD.

AND BREATHE - REBECCA DENNIS

I HAVE ONLY JUST DISCOVERED THE IDEA OF TRANSFORMATIONAL BREATH, BUT I FEEL REALLY EXCITED ABOUT THE POTENTIAL HEALING POWER IT HAS. THIS BOOK GUIDES YOU THROUGH BREATHING TECHNIQUES THAT CAN HELP RELEASE OLD PATTERNS, STRESS, TRAUMA AND FALSE BELIEFS. IT'S ALSO FULL OF STORIES OF PEOPLE WHOSE LIVES HAVE BEEN CHANGED BY THE SIMPLE ACT OF CONSCIOUS BREATHING.

And Breathe — Rebecca Dennis

THE COMPLETE GUIDE TO CONSCIOUS BREATHING

RADICAL ACCEPTANCE — TARA BRACH

THE CHILD IN YOU — THE BREAKTHROUGH METHOD FOR BRINGING OUT YOUR AUTHENTIC SELF — STEFANIE STAHL

THE GIFT — EDITH EGER

GABOR MATÉ When the BODY SAYS NO

BIG MAGIC — ELIZABETH GILBERT

RADICAL ACCEPTANCE - TARA BRACH

I AM A BIG FAN OF TARA'S MEDITATIONS. THIS is A VERY COMFORTING and NOURISHING READ. RADICAL ACCEPTANCE is a COMMITMENT TO THE TRUTH OF EXPERIENCE AS IT is RIGHT NOW, ACCEPTING WHATEVER WE FIND WITH GENUINE COMPASSION.

THE CHILD IN YOU - STEFANIE STAHL

EVEN IF YOU THINK YOU DIDN'T HAVE ANY TRAUMA IN YOUR CHILDHOOD, THERE WILL BE AREAS WHERE YOU WERE FORCED to REPRESS YOUR TRUE SELF, WHICH WILL IMPACT THE WAY YOU LIVE YOUR LIFE TODAY. STEFANIE GUIDES YOU THROUGH TECHNIQUES AND WAYS TO BEFRIEND and NUTURE YOUR INNER CHILD.

THE GIFT - EDITH EGER

EDITH EGER is A HOLOCAUST SURVIVOR OF AUSCHWITZ; SHE is TRULY INSPIRATIONAL. THIS BOOK PROVIDES A HANDS-ON GUIDE THAT GENTLY ENCOURAGES US TO CHANGE THE THOUGHTS AND BEHAVIOURS THAT MAY BE KEEPING US IMPRISONED IN THE PAST.

WHEN THE BODY SAYS NO - GABOR MATÉ

A WONDERFUL BOOK BY THE AMAZING GABOR MATÉ DISCUSSING HOW REPRESSED EMOTIONS CAN LEAD to PHYSICAL ILLNESS. IT HELPED ME MAKE SENSE OF QUITE A FEW THINGS.

BIG MAGIC - ELIZABETH GILBERT

'A CREATIVE LIFE IS AN AMPLIFIED LIFE. IT'S A BIGGER LIFE, A HAPPIER LIFE, an EXPANDED LIFE, AND A HELL OF A LOT MORE INTERESTING LIFE. LIVING IN THIS MANNER - CONTINUALLY AND STUBBORNLY BRINGING FORTH THE JEWELS THAT are HIDDEN WITHIN YOU - IS A FINE ART, IN AND OF ITSELF.'

ACKNOWLEDGEMENTS

NATURE - FOR INSPIRING ME DAILY, and FOR OFFERING ME COMFORT DURING THE BLEAKest OF TIMES.

MY DEAR FAMILY and FRIENDS, and CRAIG and CHARLIE, THE BEST COMPANIONS, NOTHING BEATS A KITTY CUDDLE.

GILLIAN - FOR MAKING ME FEEL SAFE and SEEN, AND FOR HELPING ME INCREASE MY SELF-AWARENESS OVER THE YEARS, ALLOWING ME TO BE WITH MY ANXIETY and WHATEVER ELSE comes up.

MONICA and JOE - SO Lovely TO WORK WITH YOU AGAIN. THANKS FOR YOUR PATIENCE and FOR TRUSTING ME WITH THIS BOOK.